Best wishes,
Owen Hughes

Tasmania
Our Cities and Towns

Photographs and design by Owen Hughes

Text by Bernice Jurgeit

'GREEN GABLES'

PUBLISHED & DISTRIBUTED BY OWEN HUGHES
17 Elizabeth Street, Launceston, Tasmania 7250, Australia. Telephone: (03) 6331 1481
http://www.owenhughes.com.au/

First Published 2008

Typeset by Computer Support Tasmania, Lilydale, Tasmania 7268, Australia
Map of Tasmania © Copyright TASMAP
Colour separation, printing & binding: Dai Nippon Printing Co. Printed in Singapore.

National Library of Australia ISBN number: 978-0-9590145-8-7

Owen Hughes was born at St. Marys, Tasmania in 1940 and raised on a small East Coast farm where he developed a great love of nature and people. Owen developed a new and innovative style of photography which won him many awards throughout the years including Master of Photography and Fellow of the Australian Institute of Professional Photography. Other awards have included Australian Landscape, Australian Portrait and Australian Wedding Photographer of the Year.

Contents

List of cities and towns 3

General Overview 7 - 15

The North 16

The South 44

The East Coast 58

The West and North-West 66

Map of Tasmania 80

Front cover: *Aerial view of Bicheno, East Coast*
Back cover: *Hobart from Mt. Nelson*

List of the Cities & Towns Featured

Beaconsfield
Beauty Point
Bicheno
Binalong Bay
Blessington
Boat Harbour
Bothwell
Bridport
Burnie

Campbell Town
Coles Bay
Cradle Mountain

Deloraine
Derby
Derwent Bridge
Devonport
Dover

Evandale

Fingal
Forth
Franklin

Geeveston
George Town
Gravelly Beach
Grindlewald

Hadspen
Hamilton
Hobart
Huonville

Lady Barron
Latrobe
Launceston
Legerwood
Lilydale
Longford
Lower Crackpot
Low Head

Nabowla
New Norfolk

Oatlands
Orford

Penguin
Pipers River
Port Arthur
Pyengana

Queenstown

Richmond
Rosebery
Ross
Rossarden

St. Helens
St. Marys
Scamander
Scottsdale
Sheffield
Stanley
Strahan
Swansea

Ulverstone

Waratah
Westbury
Wynyard

Franklin Square, Hobart

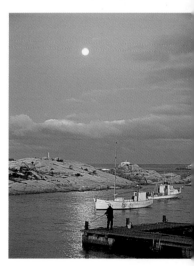

The Gulch, Bicheno

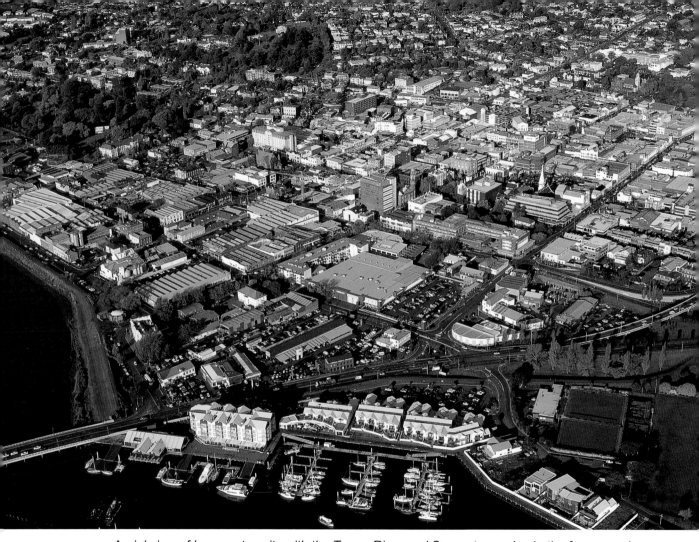

Aerial view of Launceston city with the Tamar River and Seaport complex in the foreground.

INTRODUCTION

Those explorers to whom we give credit for the brave new world discovered after the sixteenth century would not have comprehended the future possibilities of an island that lay off shore to the Great South Land of the Indian and Pacific Oceans. Tasmania as it would later come to be called was inevitably colonised by a leading power of Europe. Yet with the Dutch and Portuguese, the French and the British all exploring the boundary of the known world the future of the land identified as Palawa by its native Aboriginal people could easily have been claimed by any.

How fierce the competition became to claim territorial rights over the island remains speculative but with an increased presence in the Southern Ocean by the French who conducted many voyages of scientific exploration, a decision from the British settlement at Port Jackson in the north, (Sydney), was made to send a delegation to Van Diemen's Land with the aim of raising the flag for Britain. Their reasoning was twofold; expanding the empire to the far reaches of the world brought dominance and power and equally as important to create a penal colony to relieve England of her increasing felon population. With this premise Lieutenant John Bowen sailed forth in the Lady Nelson and the accompanying ship the Albion across the Bass Strait and into the estuary of the River Derwent in September, 1803.

While the opportunity of the new land may have evoked notions of 'milk and honey' for the white settlers the fledgling colony was placed under dire threat in the ensuing years from starvation and retaliation by the Aborigines, outraged by the invaders strange practices and the persistence of their intent. It was in these circumstances that the submission of both land and natives was wrought through blood, sweat and even more undoubtedly,

tears. The tragedy of the near annihilation of Tasmania's native people is a sorry stain on the history that has carried forth to today's modern culture.

Yet in the early years the settlers moved inland with relentless pursuit of their ideals; north and westerly up the River Derwent and her subsidiaries and southerly along the Tamar River in the north where a second settlement had taken root. Provided with free grants of land the ruling Colonial Office carved up the virgin country of the valley floors where land holders raised sheep and cattle, building their homes from the timbers of the enormous eucalypt forests and locally quarried sandstone rock. Once the prime arable land was allocated the less tameable ground on the hillsides was cleared and ploughed by the later waves of immigrants the colony sought to attract. The immigrants and settlers quickly discovered the vast resources a virgin land provides in the form of timber, quality pasture land for sheep, wool growing and dairying, minerals including gold and tin, coal and off shore a bounty of shell and scale fish.

More than 200 years on Tasmania has continued along the fortunate paths of her colonial beginnings with primary industries in timber harvesting, mining, agriculture and fishing. But the remoteness of her geographic location, at the bottom of the world and a reputation for a remarkable landscape has increasingly opened up opportunities for tourism. The island retains its original charm with a mountainous, craggy centre and delicate white beaches at the edges and with a population of just 496,000 the people reflect their good fortune in demeanour; warm, friendly and accommodating of each other, a manner that is extended to all.

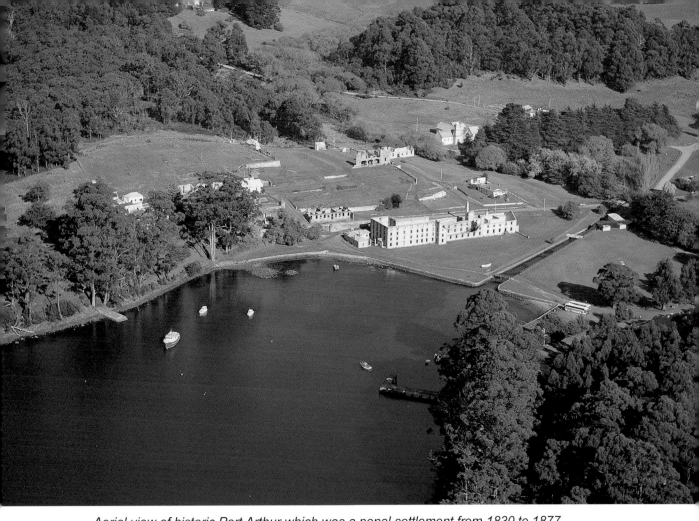

Aerial view of historic Port Arthur which was a penal settlement from 1830 to 1877.

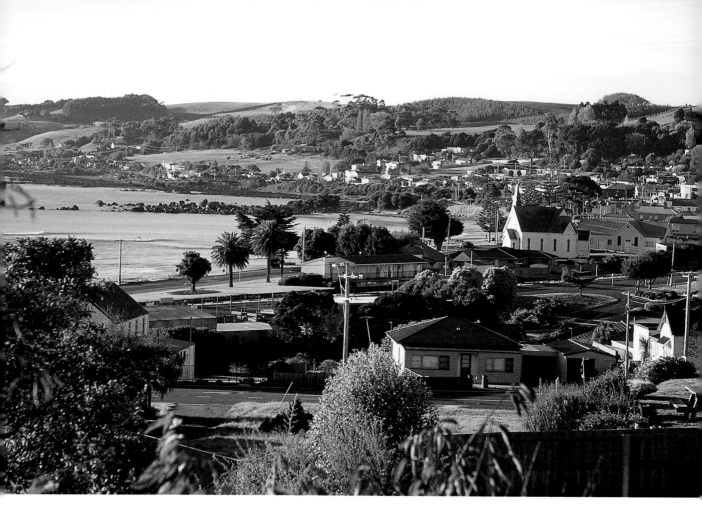

The seaside town of Penguin on the North West coast.

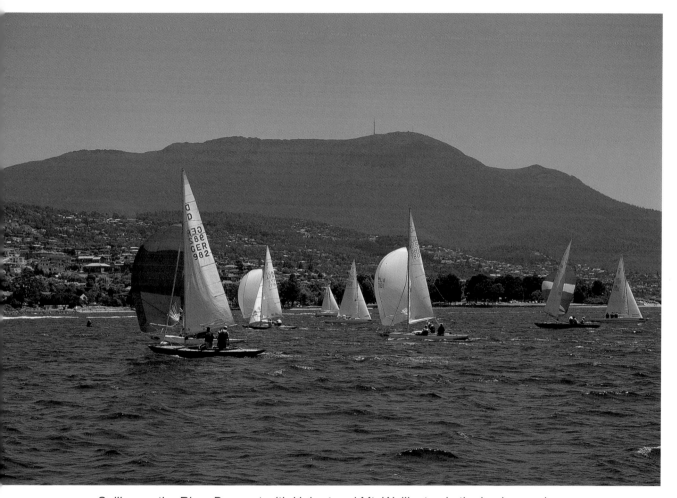

Sailing on the River Derwent with Hobart and Mt. Wellington in the background.

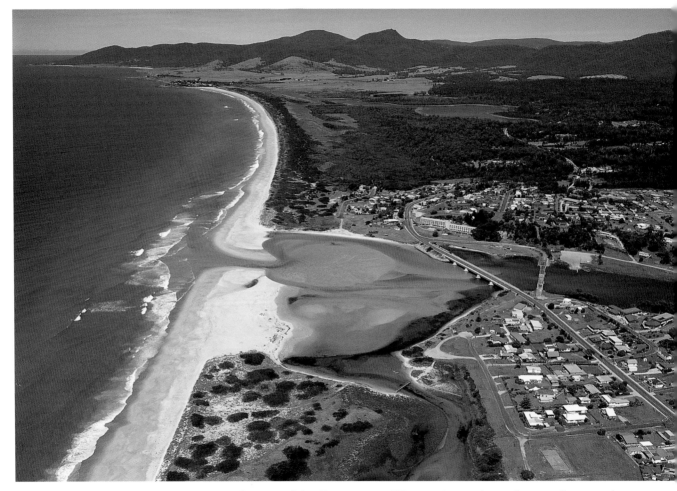

Long golden beaches are a feature of the East coast of Tasmania as shown here at Scamander.

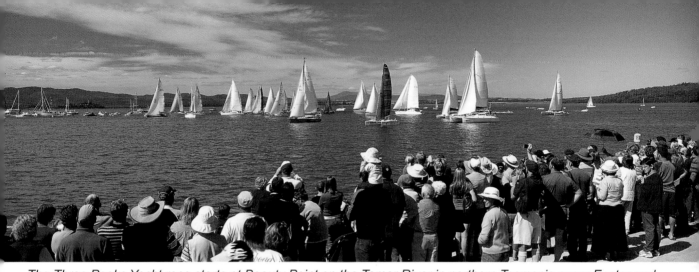

The Three Peaks Yacht race starts at Beauty Point on the Tamar River in northern Tasmania every Easter and finishes in Hobart.

Lady Barron & Franklin Sound, Flinders Island.

The Historic town of Evandale near Launceston.

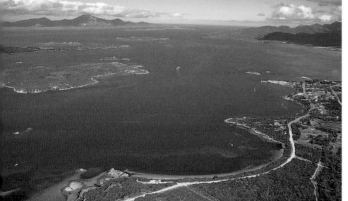

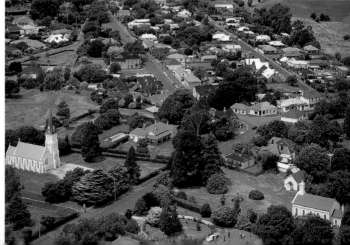

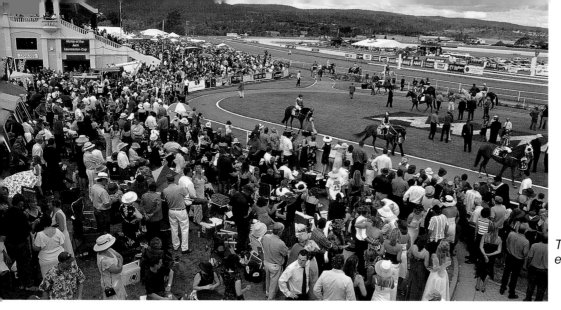

The Launceston Cup held each year in February.

Bridestowe Estate Lavender Farm at Nabowla, north east of Launceston.

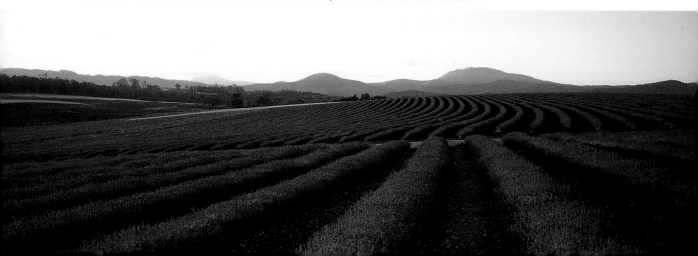

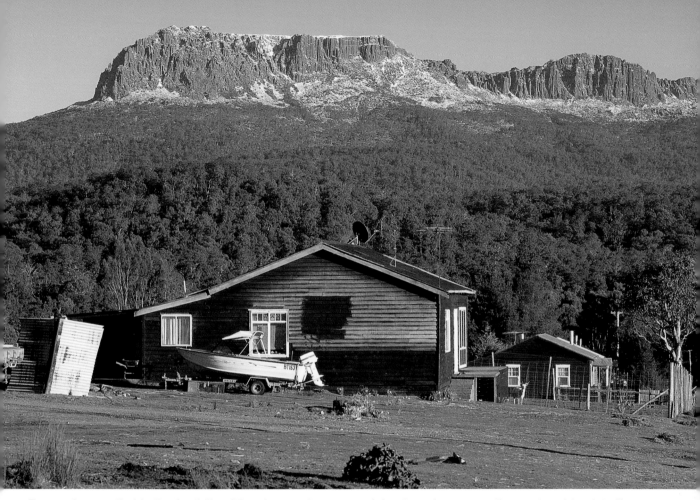

Rossarden nestled in the foothills of Ben Lomond, once a mining town is now a retirement and tourist village.

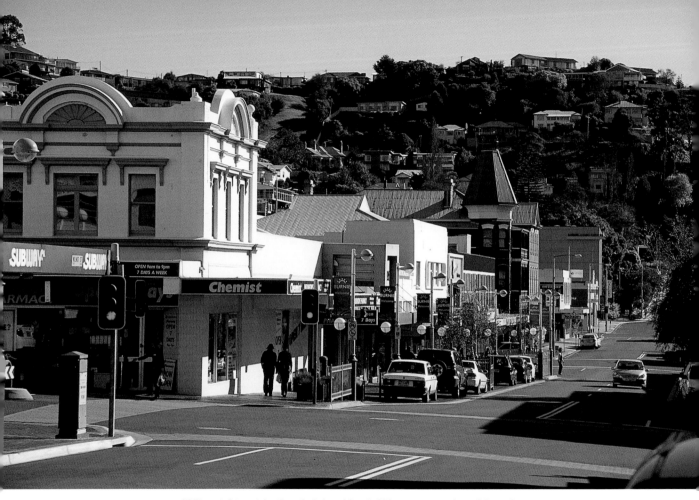

Wilmot Street in the thriving North West coast city of Burnie.

Surf fishing in the Bay of Fires Coastal Reserve on the East coast.

Far right: Anne Free gives Priscilla Babe a beer at the world famous 'Pub in the Paddock' at Pyengana.

St. Columba Falls, Pyengana.

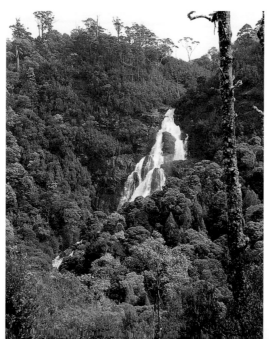

THE NORTH

Historically the northern Tamar River provided equal impetus to the growth of modern Tasmania as did its southern counterpart, the River Derwent. Launceston at its head and on the confluence of the North and South Esk rivers continues to act as the nucleus for life and progress in this part of the state. A modern airport services the domestic and commercial needs of the area supported by a well maintained network of major and minor roads. English styled towns flanked by hawthorn hedges are regularly spaced along most routes often boasting specialty shops, bakeries and information on local attractions.

In later years a thriving industry of boutique wine has developed from the vineyards along the rivers and coastline earning world recognition for its unique cool climate qualities. Similarly the rich earth has been a medium for exceptional farm produce including raspberries, cherries, apples and pears, potatoes and a range of other vegetables and fruits. The lush grasses around Scottsdale, Ringarooma and Deloraine allow for dairying and a number of small scale cheese factories are meeting the demands of modern culture producing gourmet lines of cream rich brie and fetta.

Although the boom days that saw towns and villages spring from the rise of the wealth in the ground or the forest have now passed, residents have clung to their treasured lifestyle finding innovative ways to sustain themselves. Cottage industries exist in every place where talents and skills are showcased in a plethora of tiny galleries, exclusive shops, intimate styled cafes and restaurants each harbouring a personal expression of the owner. Conversely, others have been bolder capturing the attention of world markets with exceptional fine food and dining and exclusive holiday experiences in isolated locations with pristine wilderness values.

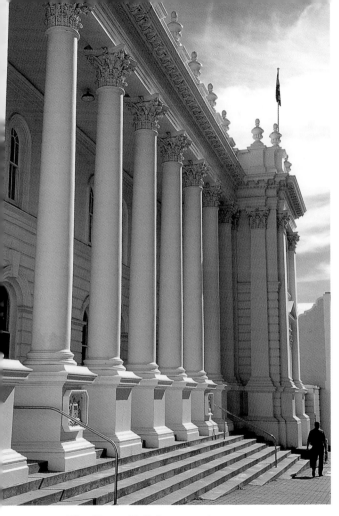

The Town Hall, Launceston.

The City of Launceston

Settled in 1806 the city of Launceston hosts one of the finest collection of Georgian buildings in the world and so nestled into the crumpling of hills at the head of the Tamar River has a particularly charming appeal. The city has a population of 98,500 and boasts a number of shopping malls, restaurant strips and entertainments and other amenities consistent with modern culture.

Launceston's waterfront offers an additional aspect to the city. With the old docks and jetties recycled, sensitive high rise apartments and marinas offer exciting lifestyle opportunities. The old Inveresk Railyard similarly has become a major arts precinct creating a fresh pulse to the city while the splendour and history of the Cataract Gorge remains unscathed. Just a short walk from the central city the Gorge grounds provide respite with gardens set amidst the tall rock cliffs. Connected by a single walkway it is possible to take in the diversity and charm of Launceston in a leisurely walk availing oneself of the many restaurants and cafés along the way. A repository for premium local produce Launceston is also home to the historic Boag's Brewery, brewers of a range of world class beers.

River Cruises run daily from Home Point and scenic helicopter flights offer a unique view over the valley and outlying mountains.

Facade on the corner of Cameron and George Streets in Launceston.

The Quadrant Mall, central Launceston.

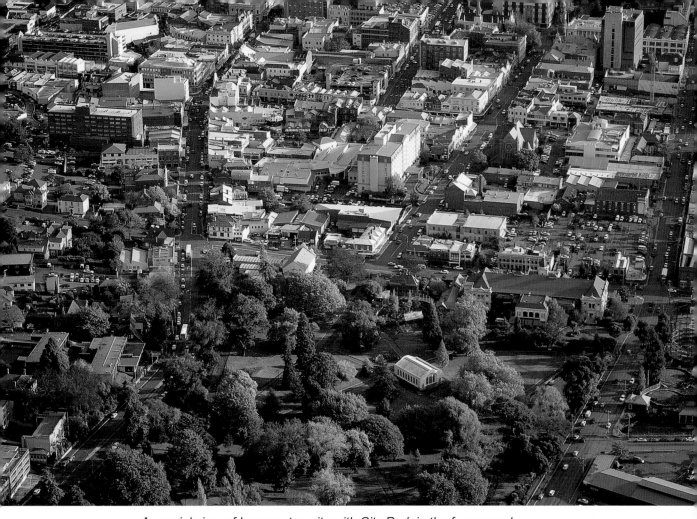

An aerial view of Launceston city with City Park in the foreground.

St. Andrews Presbyterian Church in Paterson Street.

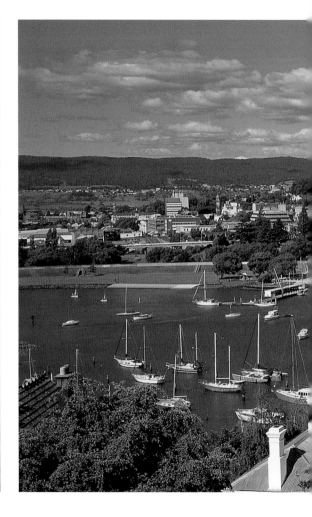

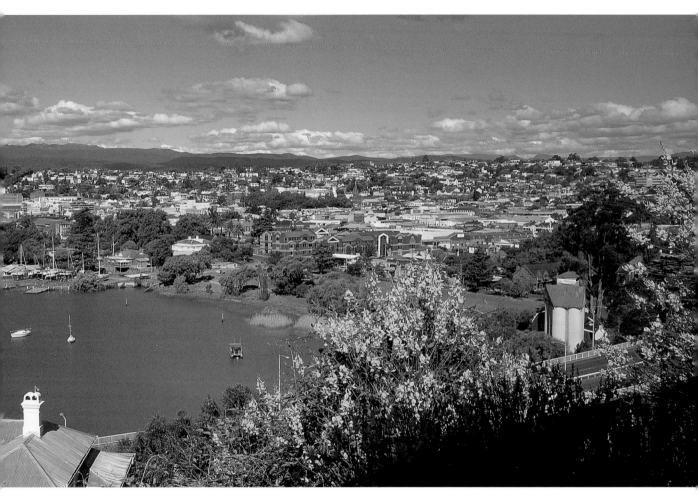

Overlooking the city of Launceston and the Tamar River from the suburb of Trevallyn.

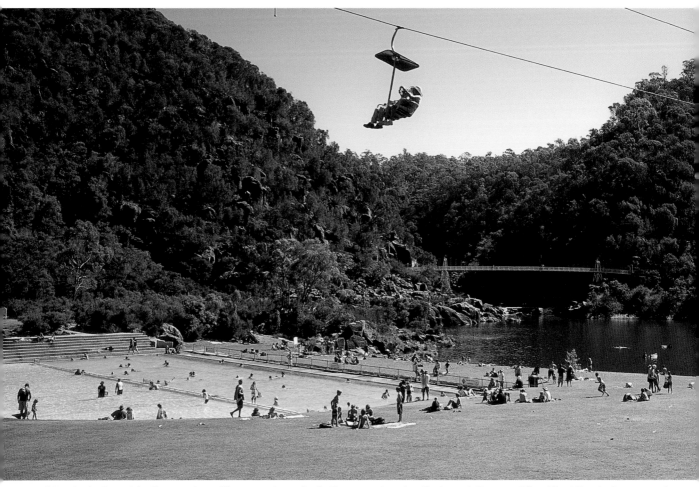

Situated almost in the centre of Launceston city is the spectacular Cataract Gorge. The First Basin is a popular swimming area during summer and the chair lift is the longest single span chair lift in the world.

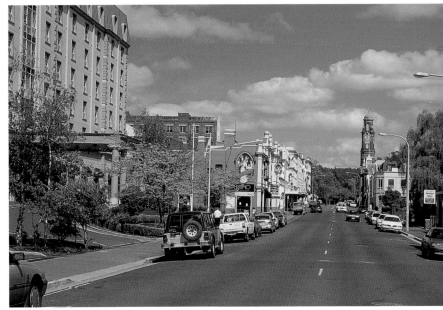

The Grand Chancellor and historic Batman Fawkner hotels are on the left with the Town Clock on the right in Cameron Street.

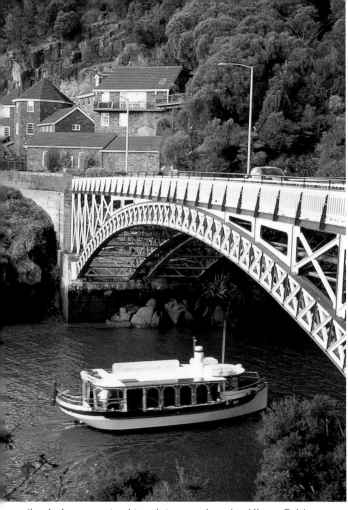

'Lady Launceston' tourist vessel under Kings Bridge (1864).

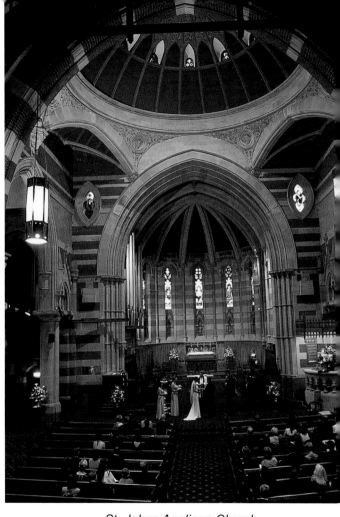

St. Johns Anglican Church.

Alfresco dining, Charles St.

Prince's Square.

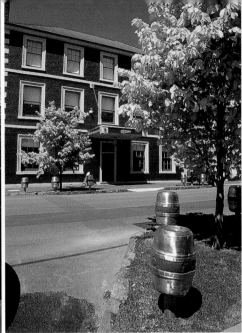

Boags Brewery, William St.

Launceston cycling classic.

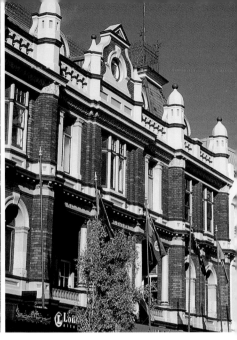

Historic facade, The Avenue.

Brisbane St. Mall.

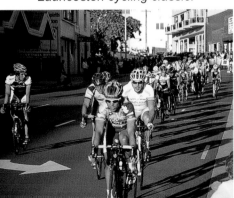

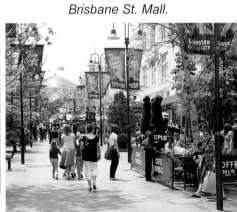

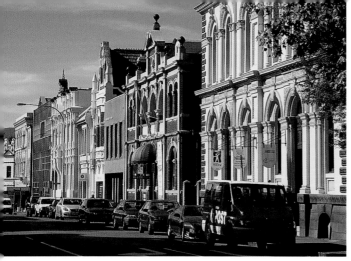

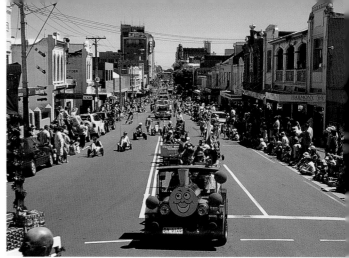

Historic buildings, Cameron St.

Christmas parade in St. John St.

The Avenue, Brisbane St.

Tasmanian Symphony Orchestra in Launceston City Park.

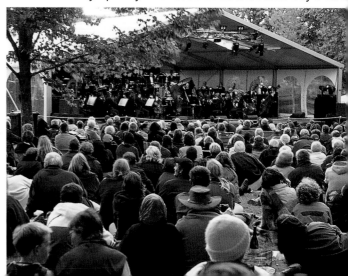

Autumn in Launceston's City Park.

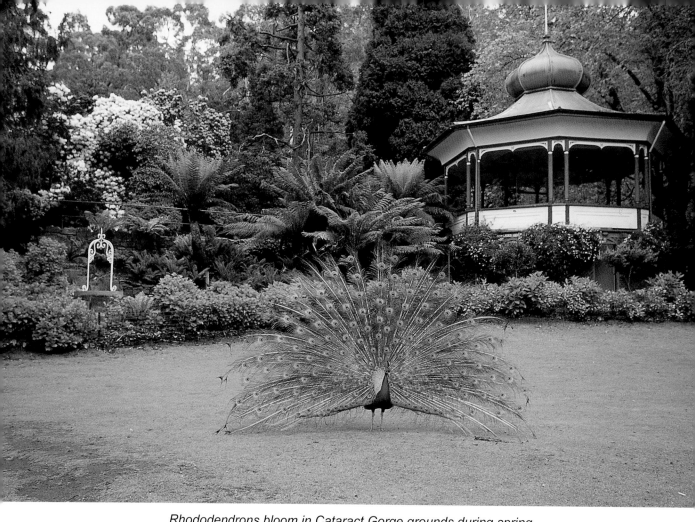

Rhododendrons bloom in Cataract Gorge grounds during spring.

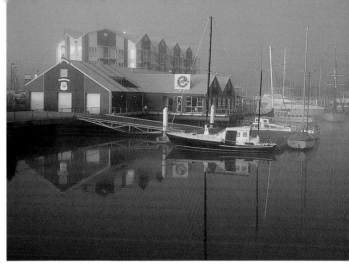

Facade on Shields Heritage building, Cameron St.

Morning mist at Seaport, Tamar River.

Aerial view of Country Club Resort.

Historic terraces in Cimitiere St.

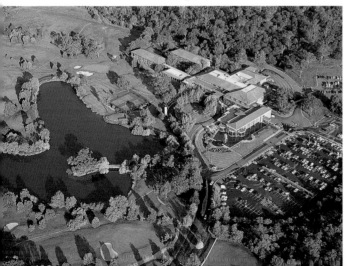

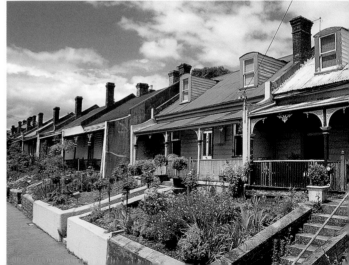

Northern Towns

Smaller centres derived from traditional industries line either side of the Tamar River connected by the dramatic span of the Batman Bridge. Attracted by its Tyrolese appearance, Tasmania's later immigrants created a piece of European homeland in Grindlewald a lofty village on the western side of the river. Further north Beaconsfield has mined gold ore since 1877 and has a thrilling history both old and recent. At the nearby water's edge the towns of Beauty Point and Gravelly Beach offer sailing, fishing and beach side fun in the relative safety of the estuary throughout all seasons.

George Town near the mouth of the river paradoxically reveals the oldest and the newest aspects of the region. With the nearby historic Low Head Pilot Station dating from 1805 the town fully emerged in the 1950's with the introduction of nearby smelters still in operation.

South of Launceston grown largely on the success of wool production the towns of Longford, Cressy, Campbell Town and Ross have maintained many of their historic values. Picturesque with modern savvy they continue to provide for local needs while blending practical living with chic shopping and an eloquent café culture.

At Scottsdale, Branxholm or Deloraine the earth lies rich and red on the slopes, the agriculture is intensive and the towns strong in community and industry.

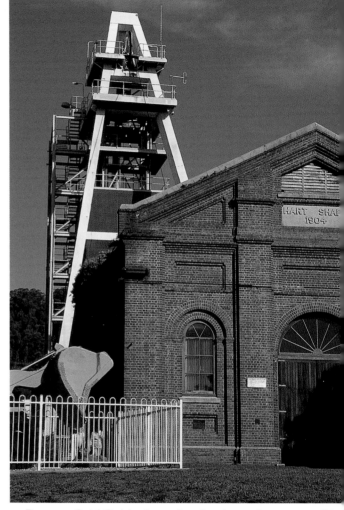

Beaconsfield Gold mine, site of a dramatic rescue of tw miners in 2006.

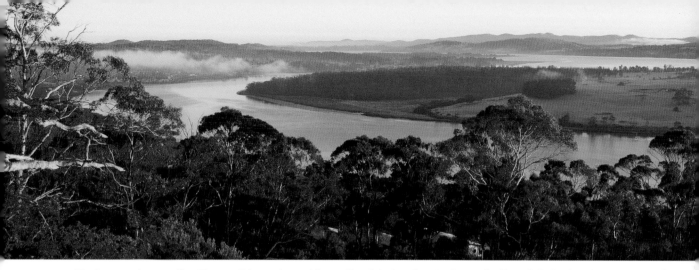

Early morning on the Tamar River viewed from Brady's Lookout. Gravelly Beach is in the distance.

Bass and Flinders Centre, George Town.

The Pilot Station, Low Head.

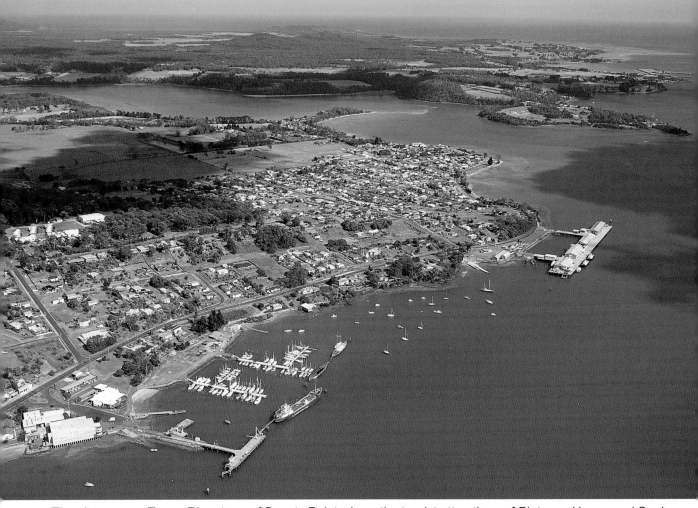

The picturesque Tamar River town of Beauty Point where the tourist attractions of Platypus House and Seahorse World are situated on the wharf.

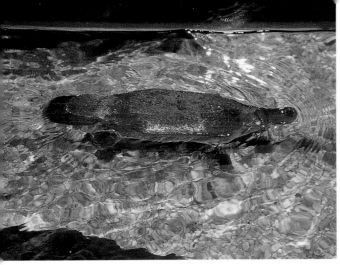

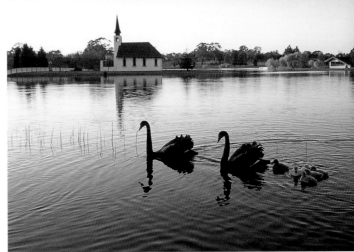

A platypus at Platypus House.

Family of swans at Grindlewald.

Robert Warren with a white echidna, and wedgetail eagles, at Tasmania Zoo, Launceston Lakes.

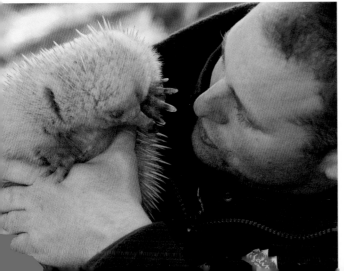

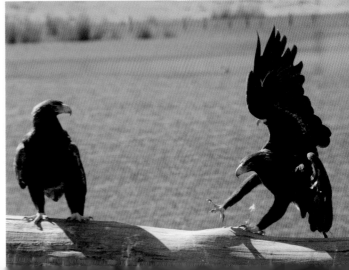

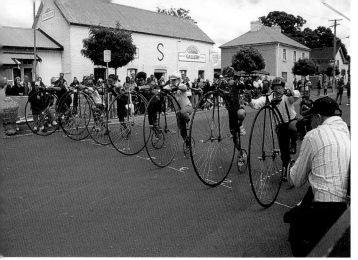

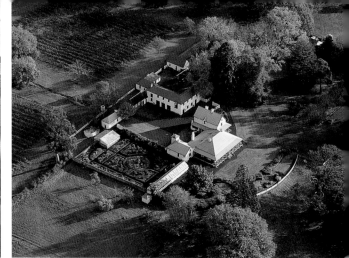

Penny farthing races at Evandale.

Historic Entally House, 1819.

Longford, about 15 minutes south of Launceston.

Michael McWilliams at Longford antiques.

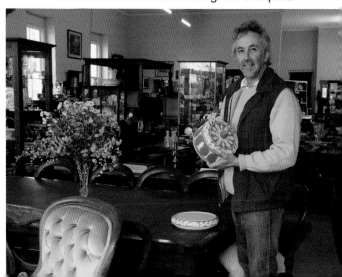

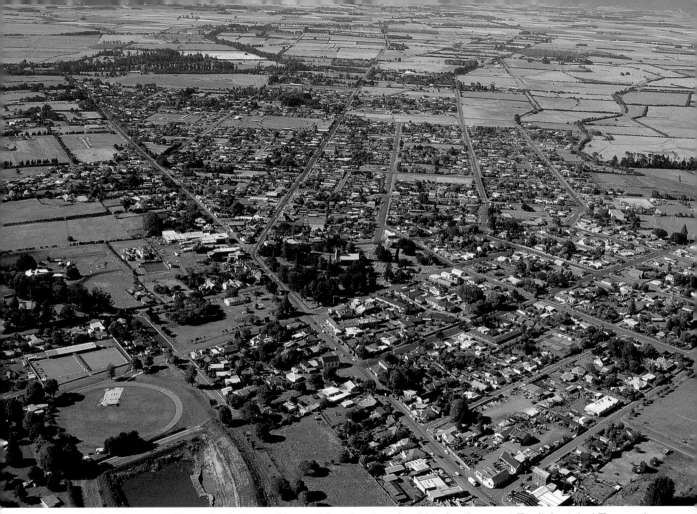

The northern midlands town of Longford situated in vast farmland and said to be the most English styled Tasmanian town because of its historic buildings and hawthorn hedges.

Winter scene in the small farming community of Upper Blessington set in the foothills of Ben Lomond.

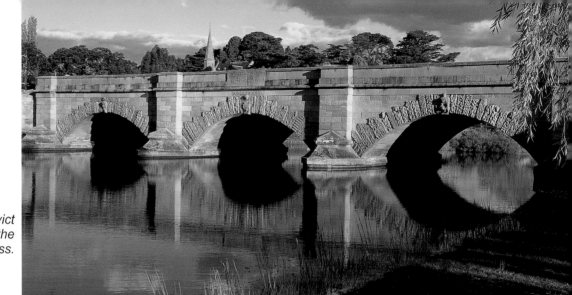

The decorative convict built bridge (1834) in the midlands town of Ross.

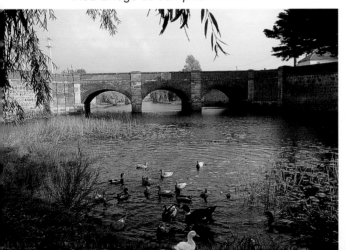

Red Bridge at Campbell Town.

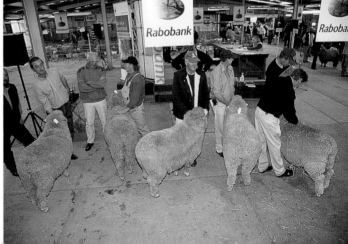

Judging of prize sheep at Campbell Town show.

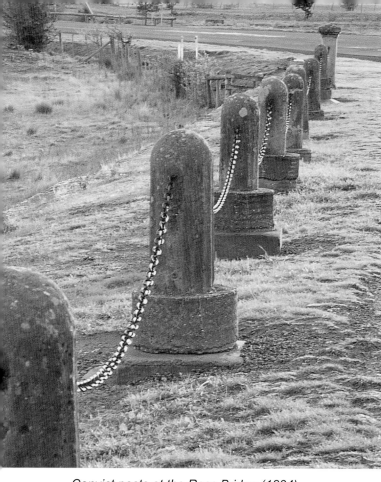

Convict posts at the Ross Bridge (1834).

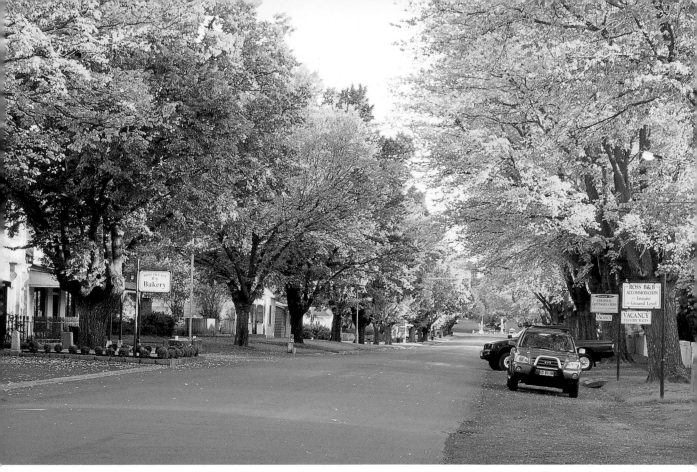

The historic rural town of Ross off the Heritage Highway between Launceston and Hobart. There are several attractions in Ross including the Tasmanian Wool Centre, restaurants and gift shops.

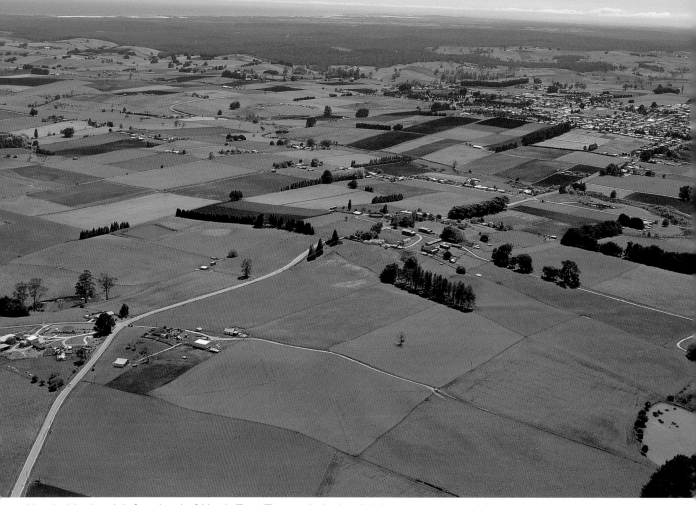

Nestled in the rich farmland of North East Tasmania is the thriving community of Scottsdale about one hours drive from Launceston through rainforest and rural towns.

Bardenhagen's General Store at Lilydale.

Forestry Tasmania Eco Centre, Scottsdale.

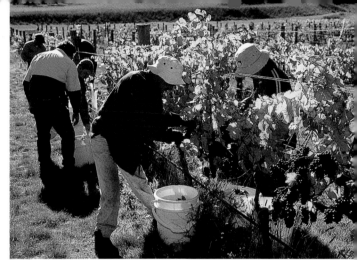

Pipers Brook Vineyard and winery north of Launceston.
Croquet Lawn Beach, Bridport.

National Trust homestead, Clarendon near Evandale is open daily.

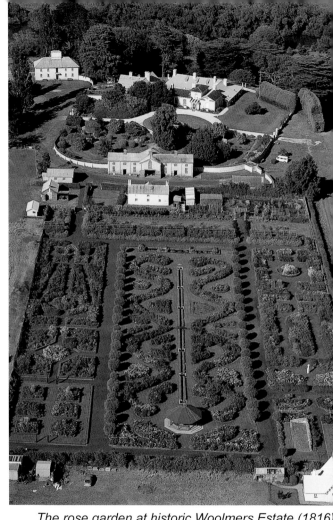

The rose garden at historic Woolmers Estate (1816) near Longford.

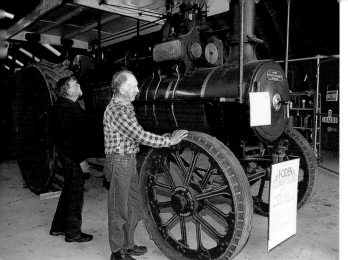

Pearns Steam World at Westbury.

Deloraine, about 30 minutes west of Launceston.

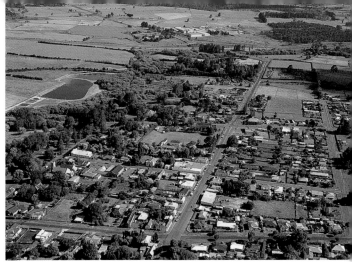

The rural town of Westbury is about 20 minutes from Launceston.
The Meander River and the Old Mill at Deloraine.

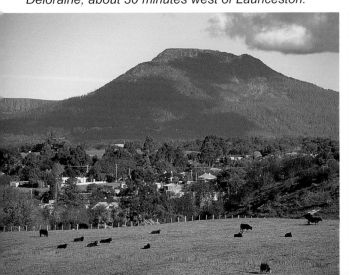

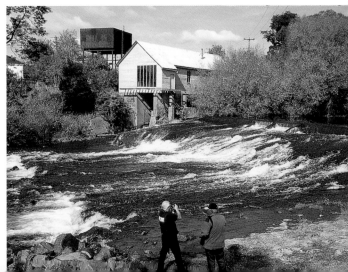

THE SOUTH

Punctuated with the capital city of Hobart southern Tasmania evolved in a similar manner to its northern counterpart. A riverside settlement emerging in time as the service centre for outlying commerce and industry the south of the island had the addition of being the administrative centre and the machine for its infamous convict penal colony. Sandstone carved blocks using convict labour characterise much of the city and many of the outlying villages and hamlets. Not least is the ruin of Port Arthur Penal Settlement on the Tasman Peninsula which housed British felons until 1877. Yet the wretchedness of these dark days has emerged triumphantly in the romantic village culture indicative of many of these sandstone towns. Bright and busy, a country way of life is retained and is indicative of the lifestyle of the island.

Aside from the River Derwent with its lofty origins in Tasmania's World Heritage central wilderness, the Coal, Jordan and Huon River valleys have done much for the development and sustaining of industry as with other places. Fruit growing, mainly apples has occurred in the Huon Valley since settlement while more to the east vineyards grew rapidly in number throughout the 1990's.

Flanked by the rugged wilderness of the South West National Park the spread of towns occurs mainly in the south east where the coast line is intricate and often spectacular. Some of the quieter bays support fish farming and oyster growing and water sports feature all year round; kayaking, boating and sailing. Boat and ship building has seen a resurgence encouraged by the opportunities of the landscape and the availability of suitable timber from the nearby southern forests.

Commercial life in the capital still provides much of the employment in the south but the innovativeness of the people inspired perhaps by the unique qualities of their environment has allowed many others to realise their dreams in the arts, music and literature for which Tasmania has a strong reputation.

The City of Hobart

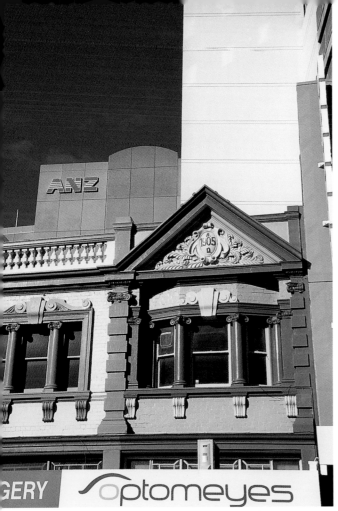

A mixture of historic and new buildings in Collins Street, Hobart.

Tasmania's capital city Hobart extends from Sullivans Cove at its centre, along the bays and inlets of the River Derwent tucking neatly under the lea of Mount Wellington. With a population of 200,000 Hobart is Tasmania's nucleus for commerce and government, arts and entertainment and an exclusive centre for shopping and dining opportunities. Hosting many major festivals throughout the year the world renowned 'Taste of Tasmania' showcases the best of premium food and wine from local producers. Similarly the 'Wooden Boat Festival' is an opportunity to reminisce the past and admire the skills retained by local craftsmen.

Life on the docks displays style and fashion; gourmet restaurants, specialty shopping, markets and entertainments are an attraction for passing cruise and naval vessels. Ferries ply the shores and pleasure cruises run daily.

There is more though, to the cosmopolitan bustle of the water side. The mountain's escarpment offers a chance for escape just ten minutes from the city centre. Bush tracks, rock climbing and cycling are easily accommodated within the scrubby forest at Hobart's edge while a short drive to the top of the mountain will present unbelievable views to the eastern corner of the island and simultaneous access to the snows and secrets of Tasmania's great wilderness.

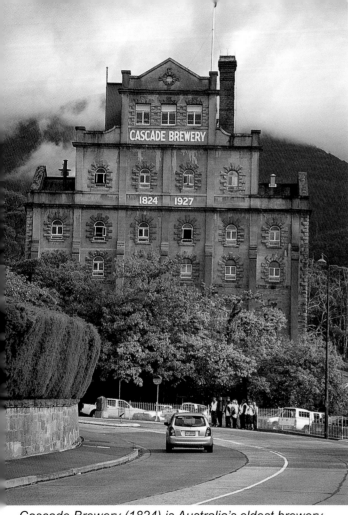

Cascade Brewery (1824) is Australia's oldest brewery.

Cat and Fiddle arcade forms part of Hobart's cultural city shopping scene.

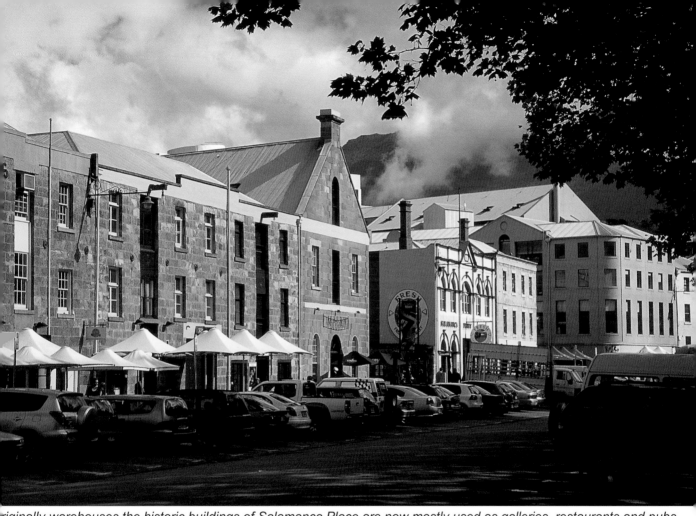

riginally warehouses the historic buildings of Salamanca Place are now mostly used as galleries, restaurants and pubs. Salamanca Market is held here every Saturday.

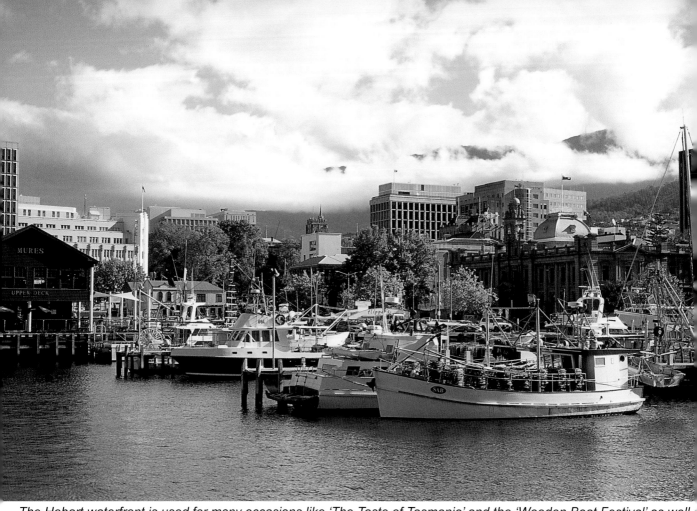

The Hobart waterfront is used for many occasions like 'The Taste of Tasmania' and the 'Wooden Boat Festival' as well as every day use for fishing boats and cruise ships. Mist covered Mt. Wellington is in the background.

St. David's Park adjacent to Salamanca Place.

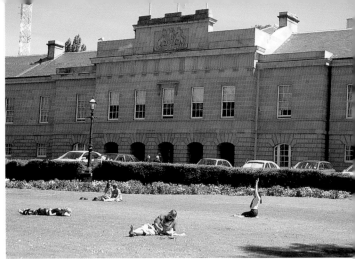

Flowers bloom during summer in Parliament Square.

Alfresco dining in Salamanca Place, Hobart.

Sailing ships the Lady Nelson and
the Windeward Bound at Elizabeth St. Pier.

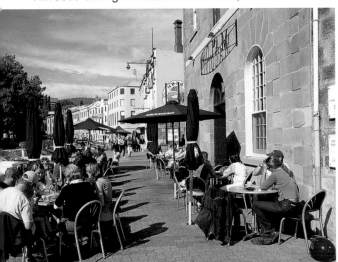

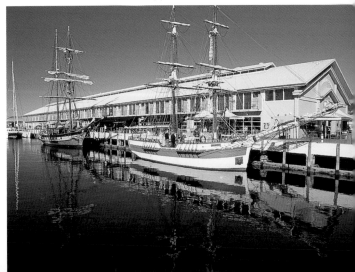

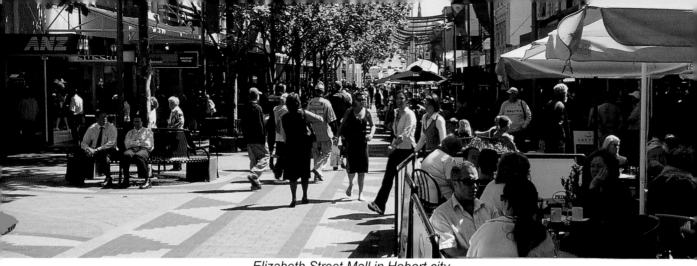

Elizabeth Street Mall in Hobart city.

Summer time on Nutgrove Beach, Sandy Bay.

*Artists Sue Fricker and Betty Gason
at work in Arthur's Circus, Battery Point.*

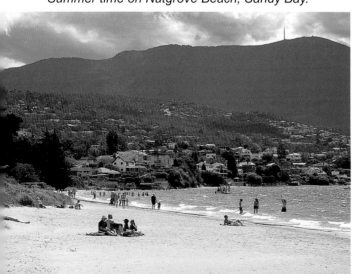

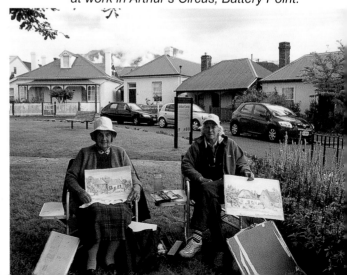

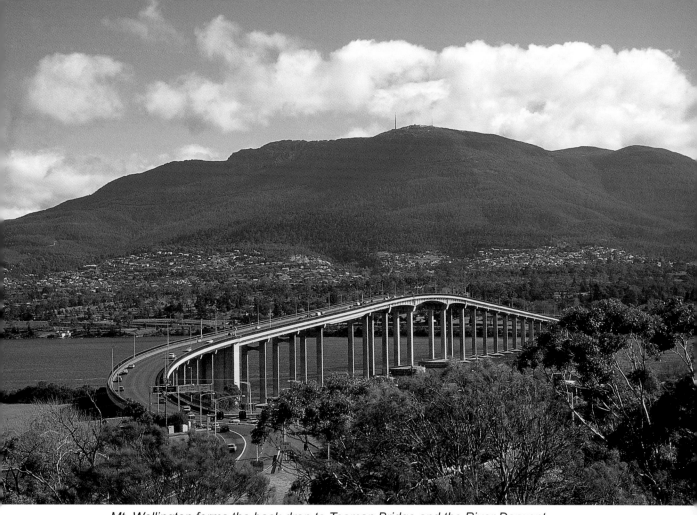

Mt. Wellington forms the back drop to Tasman Bridge and the River Derwent.

Southern Towns

With villages pocketed in the creases of the hills marking the edge of Tasmania's central high country the drive off the main highway reveals often the most picturesque scenes. North of Hobart the towns of Oatlands, Bothwell and Hamilton carved from sandstone, strongly reflects the colonial influence of their origins. Although quieter now than days past these towns and others like them have survived, offering new forms of hospitality and opportunity taking full advantage of their iconic history.

New Norfolk, on the River Derwent has made the transition more easily with the old embracing the new; industry and tourism being attracted more readily to this river town. The great southern forests of eucalyptus, pine and myrtle trees has sustained New Norfolk and other southern villages like it through its provision of timber for milling, furniture and boat building. More controversially the production of woodchips has proved a successful commodity for overseas markets.

Toward the southern most point of Tasmania, villages become smaller and life is quieter as the mountainous interior squeezes out to sea the last of the arable land. Dover and Southport opposite Bruny Island in the D'Entrecasteaux Channel are the last stop south but often the first stop home for venturers of the rugged south coast.

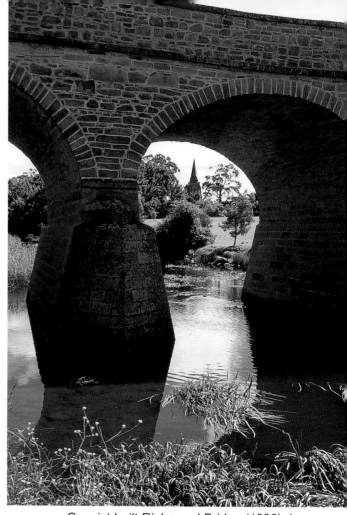

Convict built Richmond Bridge (1823), is Australia's oldest bridge.

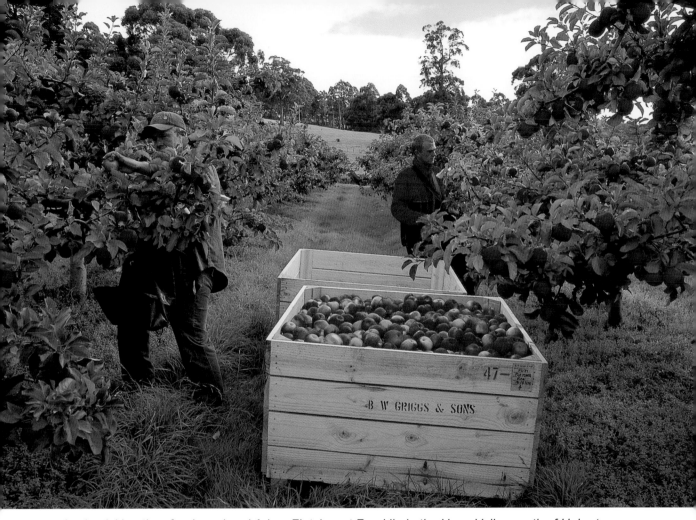

Apple picking time for Jarrod and Adam Fletcher at Franklin in the Huon Valley south of Hobart.

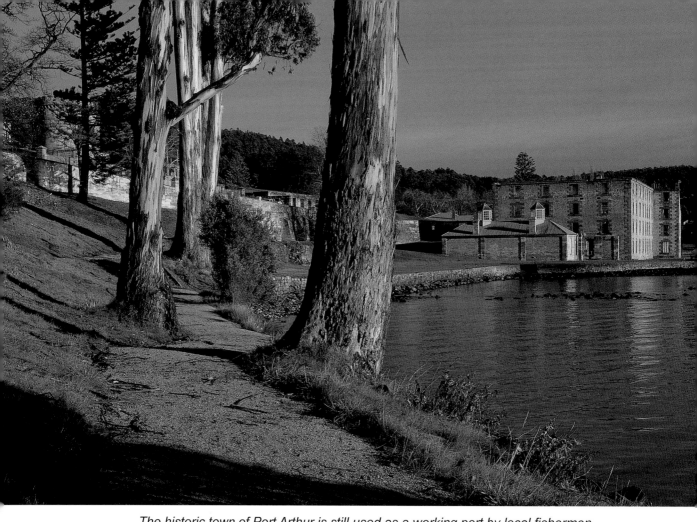

The historic town of Port Arthur is still used as a working port by local fishermen.

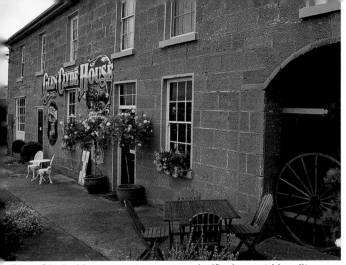

Glen Clyde House restaurant and gift shop at Hamilton.

Bothwell on the Lake Highway has Australia's oldest golf course.

Nestled in the Huon Valley is the town of Geeveston.

The historic midlands town of Oatlands.

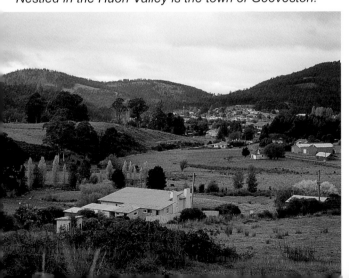

A winter's morning moonrise on Port Esperance at Dover.

Huonville in the Huon Valley.

Lou Sweetman and student Kristal Berry work at the Wooden Boat Centre at Franklin.

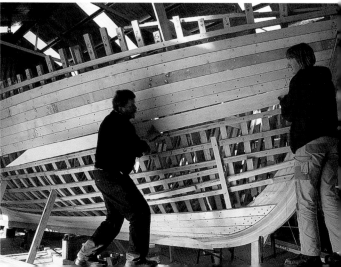

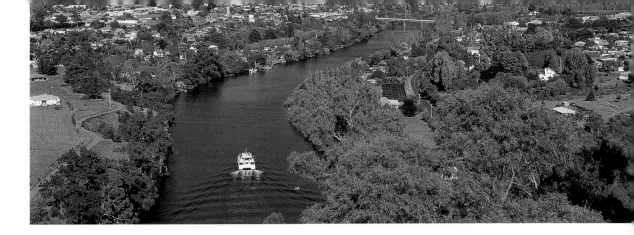

The tourist boat 'Peppermint Bay' arrives at New Norfolk on the River Derwent north of Hobart.

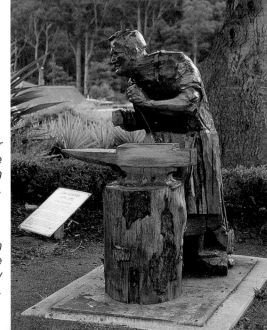

Far right: The headstone near New Norfolk of Betty King, the first white woman to set foot in Australia.

Wooden carving at Geeveston of Jim Hinchey, village blacksmith (1874 – 1951), by sculptor Bernie Tarr.

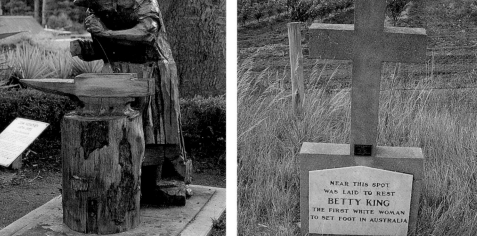

NEAR THIS SPOT
WAS LAID TO REST
BETTY KING
THE FIRST WHITE WOMAN
TO SET FOOT IN AUSTRALIA

THE EAST

With a quiet reputation for pristine bays and beaches eastern Tasmania has lost none of its beauty in the world wide race for a sea view although it is certain that such a notion was far from the minds of the early pioneers. With a more favourable climate and ready access to transport by sea, large tracts of land were granted under the authority of the ruling British powers and cleared for mainly sheep grazing. Prior to colonisation French explorers had frequented the island and surveyed many parts of the coastline. At Maria Island and Freycinet Peninsula the legacy of this exploration is still retained in the names of numerous features of the landscape.

The dominant sea based industry of the nineteenth century was whaling and sealing and intensive harvesting in the waters of the east coast brought rise to villages and towns where the land provided safe harbour for boats although Hobart remained the major centre for larger scale operations. Today commercial fishing of shellfish, lobster and scale fish still survives with small fleets operating from most ports. Depleted fish stocks worldwide have seen the emergence of aquaculture enterprises providing an alternative employment for diminishing jobs at sea. For some inland dwellers the decline of many of the boom industries has meant seizing opportunities in tourism and development in these coastal seaside towns.

Such is the spectacular appeal of Tasmania's scenic east coast that several National Parks have been created along with a number of protective reserves. Many walking tracks exist to permit visitors access to places not easily seen, amongst them the delicate scoop of world famous Wineglass Bay. The numbers of visitors attracted to the parks each year enjoy the nearby amenities of the towns of Triabunna, Orford, Swansea, Coles Bay, Bicheno and St. Helens. Other opportunities for recreation exist along the way with diving attractions, wildlife parks and the timeless appeal of deserted beaches recently voted among the best in the world.

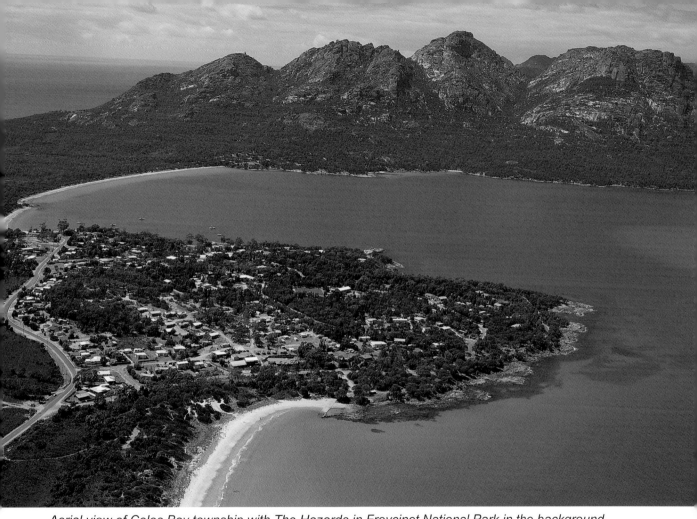

Aerial view of Coles Bay township with The Hazards in Freycinet National Park in the background.

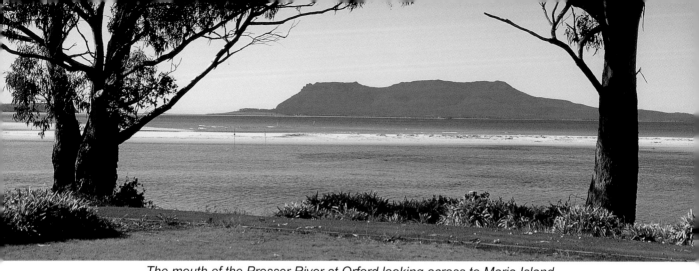

The mouth of the Prosser River at Orford looking across to Maria Island.

Aerial view of Swansea and Great Oyster Bay.

Denison Beach just north of Bicheno.

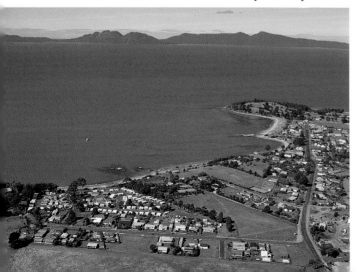

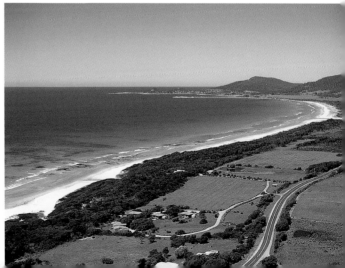

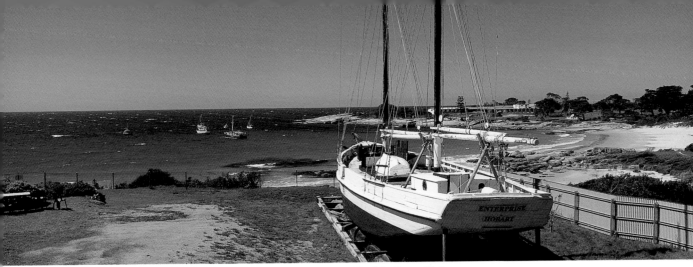

'The Enterprise' at Waub's Bay, Bicheno.

Bruce Englefield with a Tasmanian Devil, East Coast Animal & Birdlife Park.

The Blow Hole at Bicheno.

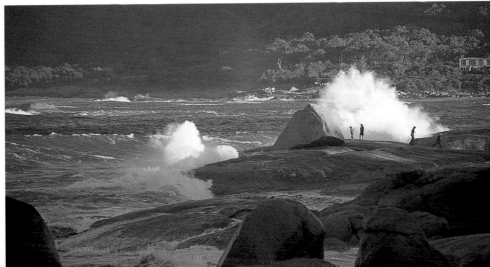

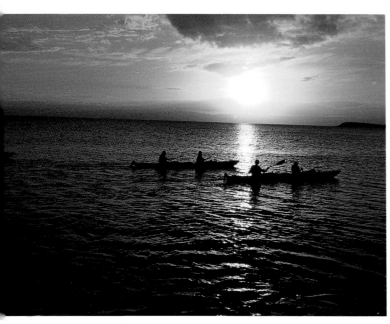

Evening kayaking tour at Coles Bay.

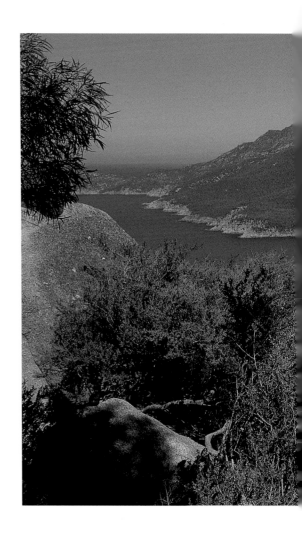

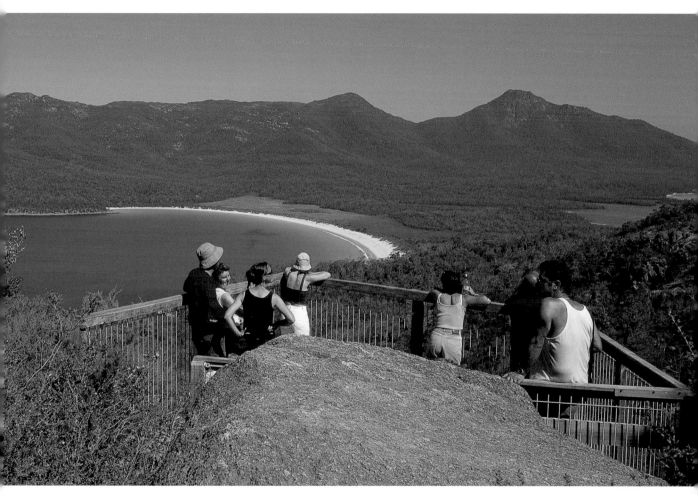

Wineglass Bay in Freycinet National Park. The viewing platform is a spectacular short walk from Coles Bay.

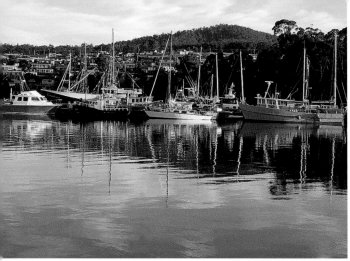

Fishing boats at St. Helens.

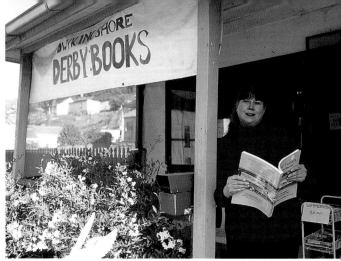

Cherie Hosking at the historic tin mining town of Derby.

*Margaret and Alan
Woodbury at 'The Shop in the Bush'.*

*War Memorial Park, Legerwood
carved by chainsaw sculptor Eddie Freeman.*

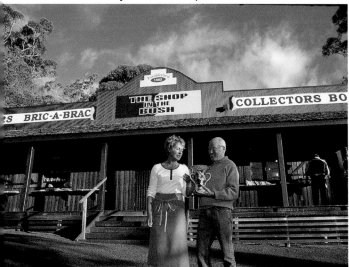

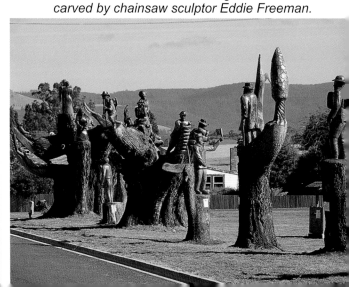

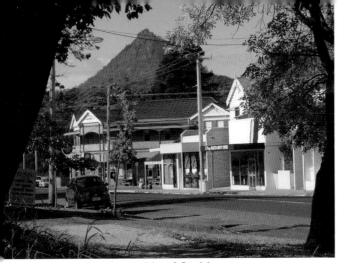

The township of St. Marys.

Holder's Store, Fingal, Ben Lomond behind.

Cheese tasting at Pyengana Dairy Company.

Summer time on the beach at Binalong Bay.

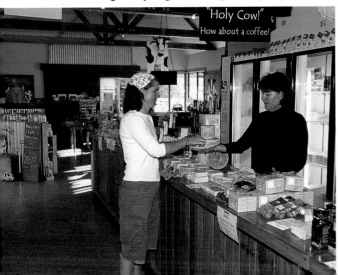

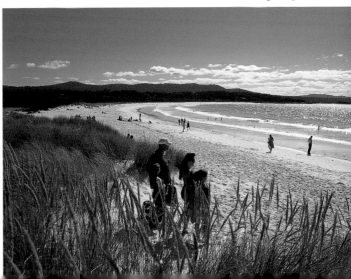

THE WEST & NORTH WEST

Tasmania's North West coast is characterised by several coastal cities and towns built on the ports and sheltered bays which gave them birth. Along the main route of the Bass Highway the city of Devonport on the mouth of the Mersey River is for many the first point of entry to the island with the passenger and vehicle ferries Spirit of Tasmania I and II, sailing daily between Tasmania and Melbourne on mainland Australia. Domestic airports at Wynyard and Devonport also operate regularly. With entrance to Cradle Mountain – Lake St. Clair and the Walls of Jerusalem National parks not too far distant the area is often a start point to Tasmania's World Heritage experiences with information readily available at visitor centres and local shops.

The journey by road along the coastal route through rich farmland of red earth is interspersed frequently by smaller centres of industry and interest capturing the curiosity of itinerant travellers. A large proportion of the region makes up the Mole Creek Karst National Park where underground at Marakoopa and King Solomon's Caves the spectacular limestone caves are open to guided tours. A chance to meet close hand with Tasmania's wild fauna is provided at several wildlife parks and a visit to one of the Forest Eco centres will offer more insights to life inside Tasmania's forests with tours and interpretive information.

Burnie at the heart of the central coast is a port city of 18,000 people where cruise ships find a northern berth. Offering every modern amenity it provides the hub for outlying reaches of Tasmania's west coast. In utter contrast to the island's east the terrain in the west is rugged with a stark beauty that has seen the boom and bust of commercial mining and the tenacity of the smaller centres of Queenstown, Zeehan, Rosebery and Strahan capitalising on their history and unique geographical location. Not least, the West Coast Wilderness Railway journey and Gordon River cruises from Macquarie Harbour are just two of the many world class attractions to be experienced.

At the furthermost tip of north western Tasmania the historic Woolnorth property is just a short journey from the fishing port of Smithton and the tiny town of Stanley nestled under the Nut where all the charm of yesteryear is held in its tiny cottages and stores, home to galleries, restaurants and cosy cafes.

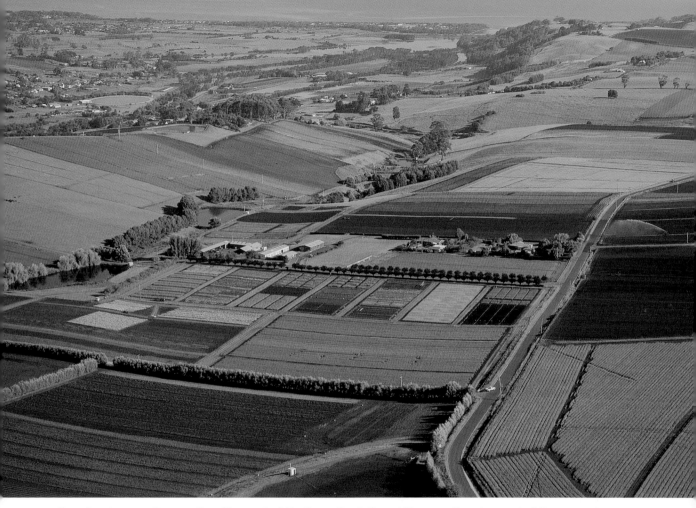

Farmlands near the small settlement of Forth on the left and Turners Beach, west of Devonport.

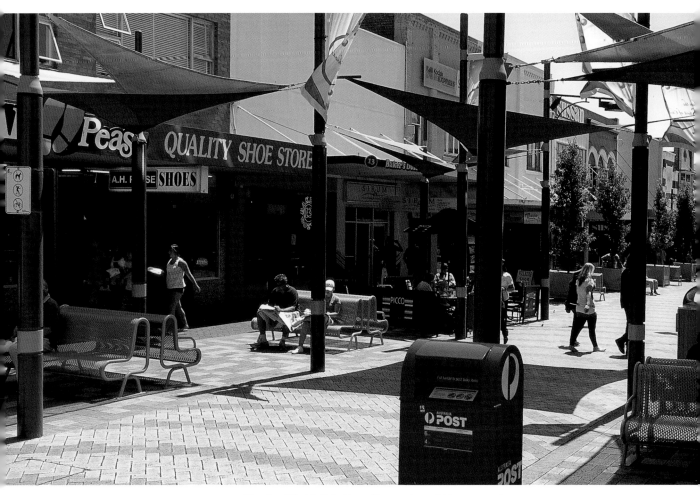

Rooke St. Mall in the city centre of Devonport.

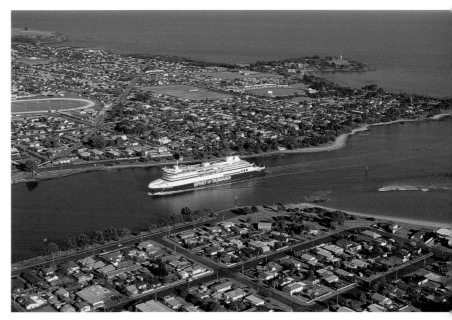

Devonport at the mouth of the Mersey River is the home port of the two Bass Strait vehicular and passenger ferries which make the crossing to Melbourne each day.

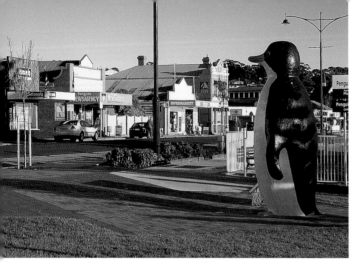

The seaside town of Penguin.

Lower Crackpot maze near Sheffield.

Sheffield nestled at the foot of Mt. Roland.

The mural town of Sheffield.

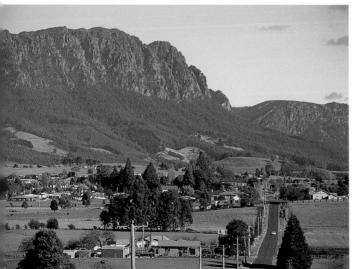

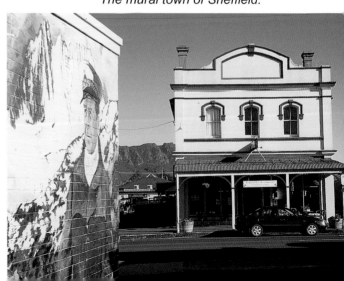

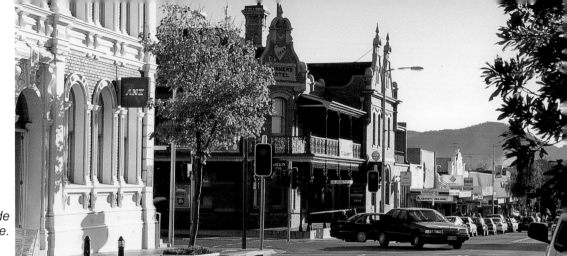

The popular seaside town of Ulverstone.

Right: Axeman's Hall of Fame reflected in the Mersey River at Bell's Parade, Latrobe.

Gilbert Street, Latrobe is just 10 minutes from Devonport.

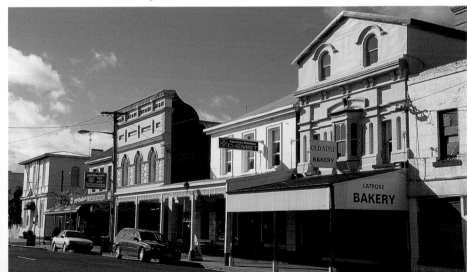

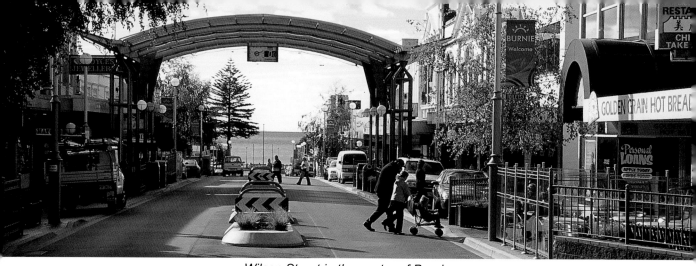

Wilson Street in the centre of Burnie.

Tanya Smith and Laurie House,
Hellyers Rd Whisky Distillery, Burnie.

Paper sculptures by Pam Thorne
and Ruth Rees at Creative Paper, Burnie.

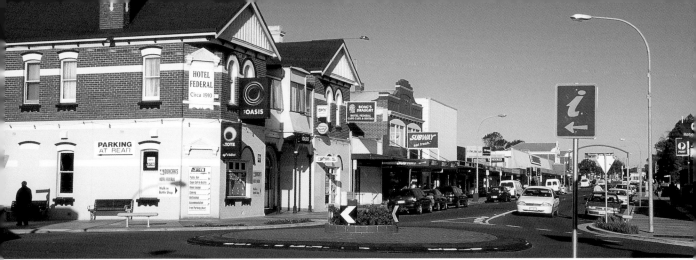

Goldie Street, Wynyard, nestled at the base of Table Cape and famous for the Tulip Festival held each spring.

Veteran car collection located at the Wynyard information centre.

Tulips on Table Cape.

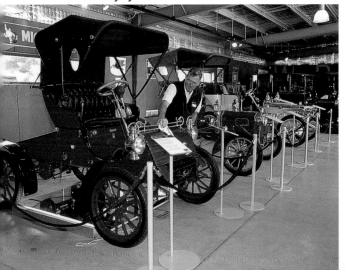

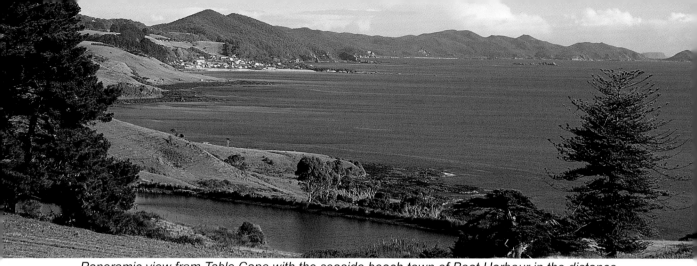

Panoramic view from Table Cape with the seaside beach town of Boat Harbour in the distance.

The Nut is the dominant feature of the historic town of Stanley.

Shops and restaurants at Stanley.

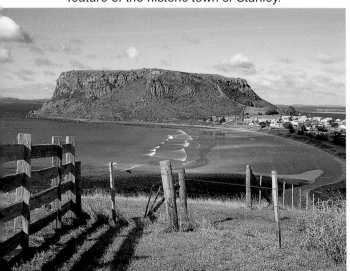

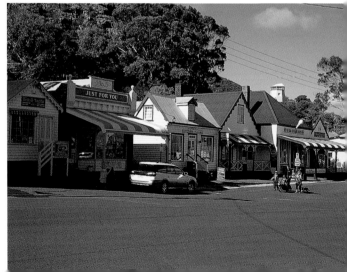

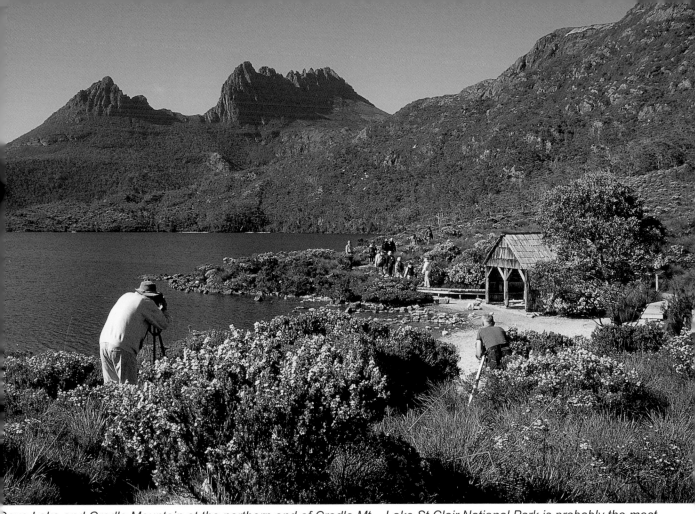

Dove Lake and Cradle Mountain at the northern end of Cradle Mt – Lake St Clair National Park is probably the most photographed scene in Tasmania. The boat shed is only a few hundred metres from the car park.

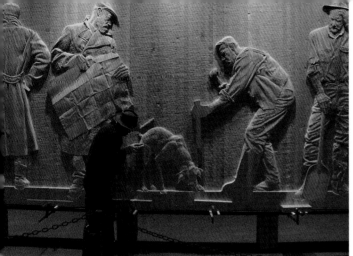

'The Wall in the Wilderness' at Derwent Bridge is an ongoing project for sculptor Greg Duncan.

Passengers await the ferry at Lake St Clair.

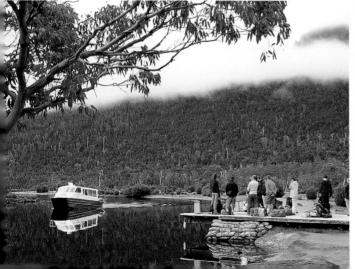

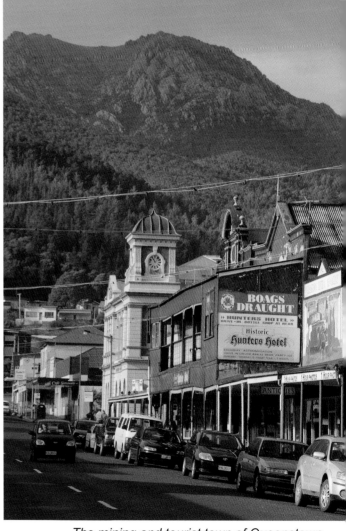

The mining and tourist town of Queenstown.

The mining town of Rosebery.

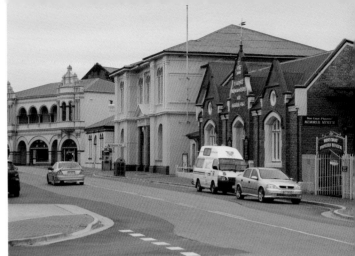

West Coast Memorial Museum, Zeehan.

Gordon River Cruises vessel, 'Lady Jane Franklin II'.

World Heritage Cruises vessel, 'The Adventurer'.

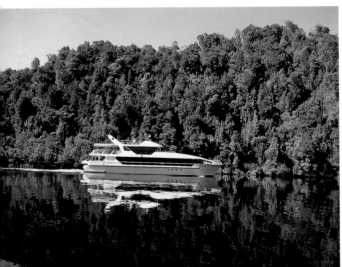

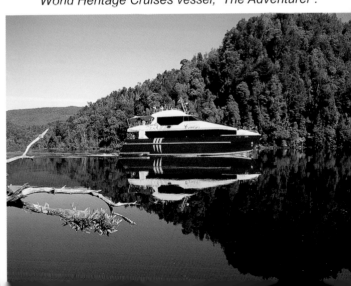

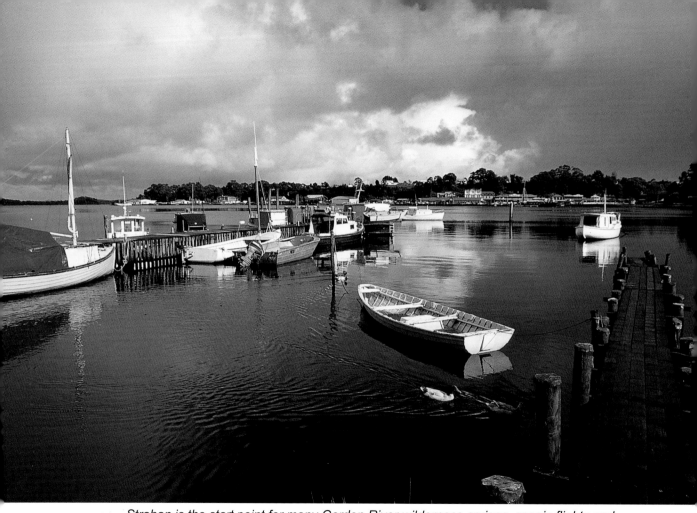

Strahan is the start point for many Gordon River wilderness cruises, scenic flights and adventure excursions.

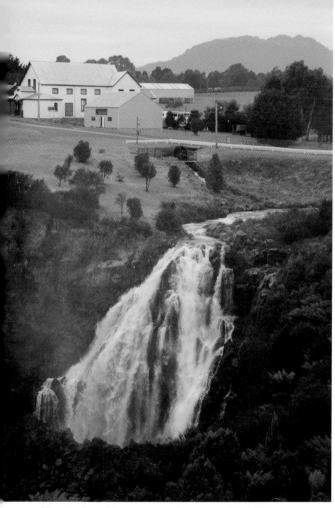

The Arthur River cascades over the cliff at Waratah.

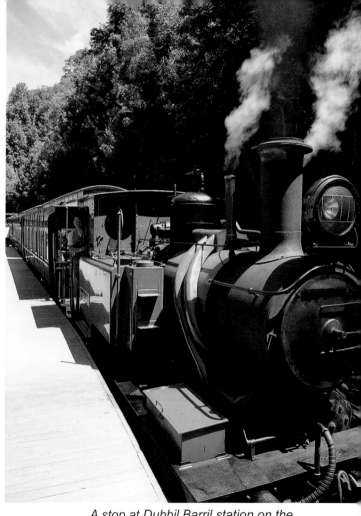

A stop at Dubbil Barril station on the West Coast Wilderness Railway.

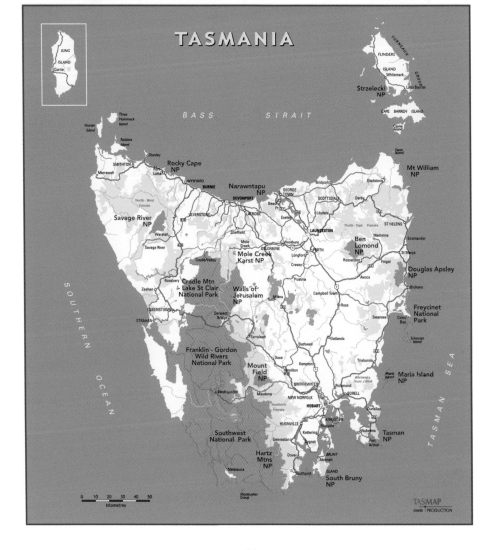